Did you know…

that most *"Cambodian silk"* sold today

is not silk,

not made in Cambodia,

not hand woven, and

not even natural fiber?

But *you* want the real thing.

Because you're *SMART.*

That's why you bought this book.

A pocket guide to

CAMBODIAN SILK

A pocket guide to
CAMBODIAN SILK

- what it is -
- where to find it -
- how to come home with a national treasure -

"The Tree of Life" **photo courtesy of Pidan Khmer**

Cornelia Srey

- A consumer guide for the 21st century -

Published by

 SINGHA BOOKS

Photographs by Lang Srey, except otherwise noted

For more information or to book an event, please contact the author
through www.TheSmellofWater.com

Library of Congress Control Number: 2016917719
ISBN-13: 978-1539091615 (paperback)
CreateSpace Independent Publishing Platform, North Charleston, SC

Also by Cornelia Srey:

With Lang Srey, The Smell of Water –
a twelve-year-old soldier's escape from the Khmer Rouge army,
and his determination to stay alive (2014),
and the sequel, NO FRONT LINE (2017)

With Pyara Sandhu, An Account of the Wreck of the Saginaw (2017)

My most heartfelt thanks to:

Mr. Kikuo Morimoto

For his many years of research and writing,
and for granting me interviews when he was very ill.
Without his work, I could not have written this book.

Nara Chan and her brother, Seiha

For answering my questions about traditional Khmer patterns,
hour after hour after hour.

Eang Khoing Pav

For showing me rarely-seen pattern arrangements,
so I could develop a standard classification system
for the many types of Cambodian silk.

George Ann Gillespie

For generously adding pre-war pieces to my research stock.

Dalign Seng

For helping me understand why tourists looking for silk
end up in the wrong place.

Lina Lem

For her encouragement, always smiling.

Pidan Khmer

For all they do for Cambodia.

Harumi Sekiguchi

For giving me that first book...

Pyara Bagg Sandhu

For being his mom's Webmaster.

Lang Srey

For making my research possible;
without him, there would be no books.

An elegant striped scarf from Pidan Khmer in Phnom Penh

Why Cambodian Silk? Why Now?

If you're reading this book you're probably in Cambodia – hey, you're on *vacation!* Oh, no, what's in your hand is *anything* but scholarly. I just want you to have a really nice time, and find the silk that you want.

But jump back into "normal" mode, just for a minute. So I can tell you why I wrote this little book.

Cambodia is the last place on earth where most silk is still dyed and woven by hand. Patterns came with the traders from India, Indonesia, Persia, China and beyond, and blended into new ones found nowhere else. Some are the rich, vibrant colors of Indian saris, others the delicate shades coaxed from coconut, tamarind, lychee and indigo. Silk brings out a certain elegance in anyone who wears it – even if it's just a scarf. But Cambodian silk wears like iron; a piece made into a classic style can be enjoyed for thirty years. And it's a sustainable product, kind to Mother Earth. What it all comes down to in the end, though, is that handmade silk is breathtakingly beautiful. And if you want to make Western-style clothing, Cambodian silk is the best of them all.

But it's dying out. And very quickly. The reopening of the borders and resumption of trade after the Communist period brought 21st-century mass-produced synthetics to the country, and nearly five million foreign visitors to Angkor Wat each year. This combination has been disastrous for Cambodia's weavers. Khmer women, struggling to recover from years of war, started to buy foreign-made synthetic imitations of Cambodian silk because that's all they could afford. This just increased the flow of synthetics across the borders. Tourists, with little time to shop and no consumer guides to help them, mistook these synthetics for Cambodian silk. And those who sold to them, the majority of whom are a different ethnic group than the weavers, took advantage of this (they have families to provide for, too). Most didn't really know much about the silk they were selling in the first place – they just knew what sold. Synthetics were easier to get. And profit margins were much, much higher. Well-meaning foreign visitors unknowingly increased the sale of synthetics exponentially, and tourists today are sold all kinds of things that look *nothing* like Cambodian silk. Weavers can't make up the shortfall in their sales, and more and more are going to work in factories. This is not a case of modern economics, but of *bad* ones.

I first went to Cambodia in 2000, and have returned almost every year. At first, the changes I saw in the markets were unremarkable. But by 2016 there was no longer much there that I wanted. So I started *watching,* instead of buying, and listening to visitors talk about what they *thought* they'd bought. I suddenly realized that if someone didn't do something, and quickly, Cambodian silk would disappear forever. And when I found out that Mr. Kikuo Morimoto, the greatest champion of this national treasure, was terminally ill, I stopped working on the book I had started on the origins of the patterns and started writing this one. I felt that what was missing was a consumer guide, and thought that I could get one out quickly.

But can it get worse than all of this? Yes, it can. With Westernization, and more and more of their weaving neighbors taking factory jobs, young Khmer are not learning very much about Cambodian silk. And buy much less of it than their parents did. Although now, a quarter of a century after the Communist period, they can afford to. If traditional silkmaking is to survive, young Khmer must come to appreciate what it is they're in danger of losing – one of the world's most spectacular art forms, and the one that brings more visitors to their country than anything except Angkor Wat. And appreciation comes with understanding. My husband Lang, who left Cambodia as a refugee in 1980, will work with me to have this book translated into Khmer; proceeds from sales will be used for that purpose.

Although some Cambodian silk is available in areas where a great number of refugees have been resettled (such as Long Beach, California, and Lowell, Massachusetts), and where it's in high demand (Paris), there is little of it outside of Cambodia. And if you try to buy it over the Internet, you have no idea what you're getting (and will pay a shipping charge more than the price of the piece). So to see Cambodian silk, you have to get on a plane – if you're not here in the country already.

This book will tell you what real Cambodian silk is, where to find it, and how to buy it. And even if you're not interested in the fine brocades and ikats – you just want a luxurious blanket, or a really good scarf for hiking back home – it will give you the information you need to find exactly what you're looking for.

OK, you can go back to vacation mode now. You'll meet many gracious and creative people in Cambodia, and have some once-in-a-lifetime adventures. Have a *wonderful* stay.

Cornelia Srey

TIP → **If your schedule for seeing the temples of Angkor doesn't give you time to read this book before you look for silk, turn to the <u>Quick Shopping Guide</u> on page 43.**

Table of Contents

Where do I look for silk?

Siem Reap

Phnom Penh

Head out for a Weaving Village!

The Silk of Legend

We do not know with certainty when the Khmer first began making silk. We do know that the people of the Mekong Delta believed to be their forbearers were engaged in international trade by the beginning of the Christian era, as evidenced by Roman coins and Indian commercial seals found at the ancient port of Oc-Eo. What followed was more than a millennium of Indianization, and it is generally accepted that the dying and weaving techniques used in Cambodia today (and many of the patterns) came from India. There were other kingdoms in Southeast Asia that underwent a similar Indianization, and they influenced Cambodian silkmaking, too.

The designs are usually things that surrounded the weaver who developed the basic pattern, whatever country she lived in. Flowers, especially jasmine. Bugs – lots of them. Spiders. Fish. Birds. Butterflies. Trees. Leaves. *Snakes.* And always, ethereal temple spires.

And then there are the colors. The pinks of young girls, the golds and reds of brides, the emeralds and indigos of a settled and contented life, the ambers and silvers of the reflective years, the ivories and charcoals of life's end… and with the next generation, it all starts over again. It's been that way since anyone can remember.

A length of silk comes first from the mind of a weaver, and then, from her hands. No one else's silk looks exactly like hers. Patterns are passed from mother to daughter, and each family makes a different one. The variety would seem to be infinite – and after a morning spent in the silk market, you begin to believe that it is.

But what first lured me in and has held me fast ever since is that it's all so *ancient.* The pipal leaf, for example, is a common design element. But… pipal trees are not native to Cambodia. They're native to India. That's the tree under which the Buddha reached enlightenment, two and a half millennia ago. And when Theravada Buddhism came to Cambodian shores, pipal trees came with it. Or perhaps they came with the first traders, two thousand years ago? Or did those early traders bring only new fabrics. Or *parts* of pipal trees, to be used in medicines. So which reached Cambodia first – the pattern, the leaf, or the tree?

**From <u>Ikat Textiles of India</u> by Chenla Desai.
Patolu sari from the collection of Ranjan Lakhani.**

Indian peacocks in an Indian patolu *(ikat) silk sari, above, and in a
contemporary Khmer Surin silk evening wrap, below (we put a penny
in the photo for scale). Compare the shape of the birds, their stance,
their flat tails and chests, the rendering of their feet, and the shapes
and position of the "stars". Both are single ikat – only the weft
(widthwise) thread has been resist dyed. The sari is from Andhra
Pradesh, and is a 20th century pattern influenced by earlier* patola
*from Gujarat. Ikat was being woven in India by the 6th century, as
evidenced by the frescoes in the Ajanta Caves.*

A row of four-petaled chan *flowers on an Angkorian temple*

This pattern survives, a thousand years later – in silk

Chorabab *in turquoise and gold on royal blue*

3

Cambodia's many ethnic groups – who makes what?

The **Khmer** are the majority group in Cambodia, and the one that has inhabited the Mekong Basin the longest; they arrived before the era of recorded history. The four peoples listed directly below are subgroups of the Khmer. In English, "Khmer" is pronounced as it's spelled (one syllable, and one vowel – the "e" like the "e" in "pet"). In the Khmer language, "Khmer" is pronounced, "Khmai" (rhymes with "try").

The homeland of the **Khmer Surin** ("Khmer from Surin") is northeastern Thailand. This area was part of the Great Khmer Empire until it was annexed by the Thai in the 15th century. Most Khmer Surin speak both Khmer and Thai.

The homeland of the **Khmer Leuu** ("Upper Khmer") is the northernmost area of Cambodia. Some have intermarried with Lao.

The homeland of the **Khmer Kandaal** ("Central Khmer") is central, northern and southern Cambodia. The Khmer of Takeo, Prey Veng and Kampong Cham provinces, famous for their ikat silk, fall into this group. The Khmer of Kandal Province, famous for their brocade silk, also fall into this group.

The homeland of the **Khmer Kraum** ("Lower Khmer") is the Mekong Delta. This group became Vietnamese by nationality when Vietnam annexed the Delta early in the 18th century. Most Khmer Kraum speak both Khmer and Vietnamese.

Each of the four Khmer groups makes Cambodian silk, and wears what they make. Each has its own distinctive patterns.

The homeland of the **Cham** (pronounced, "Chaam") was the south-central coast of Vietnam. They speak a language in the same family as Malay. The Cham who live in Cambodia today are Muslim, and most speak both Cham and Khmer. Weavers in this group make silk for their own use, and *sampot hol* (ikat silk for ankle-length sarong-like skirts) to sell to Khmer. This group has its own distinctive patterns.

Various **Chinese** groups have immigrated to Cambodia over the course of the last millennium, and intermarried with Khmer. Although the Chinese and Chinese Khmer in Cambodia do not make silk, most wholesalers ("middlemen") and retailers come from this ethnic group.

There are **Vietnamese** in Cambodia, but they do not make silk.

There are many **tribal peoples** in Cambodia's mountain ranges. They each have their own weaving traditions, but do not make silk.

When I look for Cambodian silk... <u>what</u> am I looking for?

Because not all of you will have time to read through this book before you start your search for silk, let's start with what first meets the eye.

How to assess pattern and color

A simple three-color ikat

By Cambodian standards, the piece above is considered rather coarse. The pattern is very simple, large (10-cm. repeat), irregular and uneven, and there is no border at the hemline. It's only three colors, the background color is uneven, and it was dyed with chemical dyes.

Compare it to this five-color first-quality ikat, with its intricate, regular pattern and even color, dyed with natural dyes.

© Tadashi Kumagai photo courtesy of Pidan Khmer
A first-quality five-color ikat from Pidan Khmer in Phnom Penh

Any Cambodian woman would prefer this piece, but it might not be within her means. The woman with pride in her country's long silk-making tradition, however, would choose the "coarse" ikat rather than wear an imported synthetic.

TIP → Silk with a small pattern is considered the most refined.

5

How a piece of silk is worn determines its pattern scheme

Let's begin with the two most ancient kinds of clothing. They're not sewn, but wrapped around the body instead. They're considered to be the "purest" of garments (perhaps because they're the most ancient), and so are worn for sacred ceremonies.

❖ A *lbaab* is a **straight skirt** pleated down the center like an Indian sari, and held in place by a wide gold or silver belt. Most fabrics worn as *lbaab* have a **narrow border** along the selvedge edge that wraps around the waist, and a **wide border** along the lower selvedge edge. Brides and grooms wear *lbaab* for some of their wedding ceremonies, which are spread over two or three days.

❖ A *chaungkbun* is an **Indian *dhoti,*** the pantaloon-like garment that Mahatma Gandhi wore (except longer than his – the lower selvedge edge falls between the knee and the ankle). *"Chaung"* means, "tied", and *"kbun"* is the fabric that's tied (approximately 1 metre X 3.75 metres). Most fabrics worn as *chaungkbun* have a **narrow border** along the selvedge edge that wraps around the waist, and a **wide border** along the lower selvedge edge. Some *kbun* have end panels, but this is uncommon these days. Brides and grooms, and members of bridal parties, wear *chaungkbun* for some of the wedding ceremonies. *Chaungkbun* are also worn by royalty, persons of high rank, and participants in temple ceremonies.

Because *lbaab* and *chaungkbun* are not *sewn,* they're not *hemmed.*

Fast forward to the 21st century.

❖ A *sampot* ("saamPOTE") is a sewn, ankle-length **sarong-like skirt** folded over once at the waist. It is worn by women to weddings and other dress occasions, and to the temple. Most of the fabrics worn as *sampot* have a **wide border** along the lower selvedge edge, but no narrow border along the upper selvedge (because it would be sewn into the waistband, and therefore not visible). The fabric needed for a *sampot* is half a *kbun.*

As you'll see, Cambodian silk is still sold by the *kbun* (or half *kbun):*

1 *kbun* = **1 metre X 3.75 metres** (approximately)
1 *sampot* = **1 metre X 1.87 metres** (approximately)

The many types of Cambodian silk

TIP → If you just want a scarf or blanket for Mom, skip to the **Quick Shopping Guide** on page 43.

It's easiest to describe all the different types of silk by *pattern:*

couture unpatterned silk	*pamooung* organza
couture geometric brocade silk	*pamooung bauntok chorjuung* *pamooung bauntok* (both are usually just called, "pamooung" – very confusing)
haute couture floral brocade silk	*chorabab*
couture ikat silk	*sampot hol* (or just "hol") *anloony* (or just "loong")
ikat silk tapestries	*pidan*
plaid silk	*sarong sot* *kramaa sot* (any type of silk scarf)

The words, "Cambodian silk" usually refer to *sampot hol* and *pamooung bauntok chorjuung. Sot* ("sOte") is the Khmer word for silk.

Couture (Dressmaking) Unpatterned Silk

Pamooung ("paamOOung") is silk with no pattern, but instead a distinctive shimmer created by the use of warp (lengthwise thread) and weft (widthwise thread) of contrasting colors. As the fabric moves with the wearer, the color changes. A purple warp and a green weft create the iridescent green of a duck's neck. A red warp and a yellow weft create the color of a ripe mango. A black warp gives depth to any color weft. Cambodian women make blouses of *pamooung*, having their seamstresses add piping, beading or embroidery (sometimes all three!).

There's a type of weave you'll see in stores that cater to foreigners, *lbauk*. It's characterized by a raised pattern (usually rows of diamond shapes, each one about the size of the tip of your little finger). *Lbauk* adds elegance to a plain scarf or an ikat evening wrap (see page 11 for an illustration).

7

Auhkownohsa is stiff, sheer silk. But don't worry – you won't have to learn how to pronounce this word. "Auhkownohsa" is not in common usage, so you can ask for it by its French name – organza. A few upscale stores that cater to foreigners carry fabulous embroidered wraps – ivory (très élégant), black, and colors.

Couture Geometric Brocade Silk

Pamooung bauntok chorjuung ("paamOOung bauntOk chorjUUng" or, more commonly, just "pamooung" (very confusing)), is *pamooung* with a geometric brocade border along the edge of the fabric that will touch the ankle, and a simple brocade field from the border to the waist edge. Some patterns came from India, some down the Mekong from Laos, and some are Khmer. It's worn by women as a *sampot*, for attending weddings and other dress occasions. It can also be worn by both men and women as a *chaungkbun*.

Detail of an extraordinarily fine pre-war (1960s)
pamooung bauntok chorjuung –
an army of white spiders on a golden field

Pamooung bauntok is *pamooung bauntok chorjuung* with no *chorjuung* (the border at the hemline).

Chorabab ("ChOrabab"), a rich, all-over brocade, is the haute couture of Cambodian silk. It has a wide, elaborate border along the edge of the fabric that will touch the ankle, and a complimentary brocade field from the border to the edge that will wrap around the waist. Most have a narrow border along the waist selvedge because they're meant to be worn as an unsewn *lbaab* or *chaungkbun*.

By Cambodian standards *chorabab* is very expensive, and is worn by royalty, persons of high rank, Khmer brides and grooms, and professional entertainers. Red *chorabab* is reminiscent of Indian wedding saris.

Three types of chorabab, *and one ikat (left) –*
note the difference in the brocade and ikat borders.
The two pieces on the right
are from Chan Nara in the Phnom Penh area.

Pamooung pittch ("diamond pamooung", next to the ikat), is actually chorabab, not *pamooung bauntok chorjuung,* How can you tell?

❖ It has a border along the selvedge edge that wraps around the waist (not in the photo).

❖ The border along the lower selvedge edge is a classic *chorabab* border (not a *pamooung bauntok chorjuung* border) – compare it to the two *chorabab* on the right. The pattern on the lower selvedge is a row of Angkor Wat temple spires with a stripe above it called the Bantea Srey pattern (both old Khmer designs – Bantea Srey is an Angkorian temple older than Angkor Wat).

The rows of kite shapes enclose gold dots, the "diamonds".

This piece is made with turquoise warp, red weft, and aquamarine and gold supplemental weft. It has a 16-centimetre lower border.

The *chorabab* to the right of the diamond pamooung is an economical piece, a silk / cotton blend with a larger pattern (*chan* flowers). Its Angkor Wat / Bantea Srey border is slightly different than the pieces on either side of it. This *chorabab* is made with purple warp, royal blue weft, and turquoise and gold supplemental weft. It has a 16-centimetre lower border.

The piece on the far right is 3-color *chorabab* – warp and weft of different colors, with supplemental weft of a third color (no gold or silver is used). The kite-shaped design is an aquamarine blue lotus bud enclosing a fuchsia diamond. Its Angkor Wat / Bantea Srey border is slightly different than both of the other *chorabab.* This piece is made with purple warp, fuchsia weft, and aquamarine supplemental weft. It has an 18-centimetre lower border.

You'll find more information on Cambodia's haute couture fabric in the section entitled, "More about Chorabab, the Queen of Cambodian Silk".

Sampot Hol ("saamPOTE hole"), or, more commonly, just *"hol"*, is silk with an ornate motif created by resist dying the pattern into the weft thread before the warp and weft are woven together ("single ikat", or "weft ikat"). Because most *hol* is worn by Khmer women as a *sampot*, most is comprised of two patterns that complement one another – an elaborate border along the edge of the fabric that will touch the ankle, and a less-elaborate field from the border to the waist edge. Bridal couples also wear *hol,* but as a *lbaab* or *chaungkbun.* Many patterns worn by Cambodian women today are reminiscent of traditional Indian ikat saris *(patola).* See the photographs on pages 5 (bottom), 32, 33 and 42 for examples of first-quality *sampot hol.*

Most of what was made before the Communist period was "five-color *hol".* Less-expensive two- and three-color *hol* began to appear in the mid-1980s, when the economy was beginning to recover but women still didn't have a lot of money. Most five-color is in warm shades of brown (golds, coppers, ambers and chocolates). Pastels, and colors of medium intensity, have become popular in recent years. **If you're looking for the most traditional type of couture ikat, look for "five-color *hol".*** If the pattern is very fine (the repeat is very small), it may contain six colors:

chocolate or black
amber or gold
white or silver-grey
dark red
dark or medium purple
medium green or dark blue

By Cambodian standards, *hol* is expensive. It's worn to temple, and to weddings and other dress occasions. In urban areas, men's *hol* shirts and jackets are popular. *Hol* evening wraps, some with *lbauk* weave, are available in stores that cater to foreigners.

Detail of a hol *evening wrap with* lbauk *weave*

11

More peacocks, this time with chicks!
This is sampot hol chorjuung,
and has just recently come into fashion.
It's silver on charcoal blue.
Ask for it by name at Psar Olympic in Phnom Penh.
(Note the Trees of Life between the peacocks' tails.)

The pattern on the piece above appears crisp in comparison to the one on the next page. Weavers used to use banana fiber for the ties needed in the resist dying process, but many have switched to plastic (preparing the banana fiber ties is very labor intensive).

A pearl-grey and white sampot hol *with a 26-cm. border.*
If you like wide borders but feel you're too short to wear them,
try a light-colored piece.

The piece on the previous page was made in 2016. The one above is much older. I would guess that plastic ties were used to dye the newer piece, and banana fiber ties were used to dye the older one. But the difference in the sharpness of the patterns may be due to the color contrast in each piece. Traditionalists prefer to buy pieces dyed using banana fiber ties. And *everyone* wants natural dyes.

The older piece is also softer than the newer one. It may be pre-war; some softening techniques were lost during the Khmer Rouge era.

Anloony ("anlOOny"), or, more commonly, *"loong"*, is silk with solid and geometric-ikat stripes of varying widths (all thin). When worn as a *sampot,* the stripes are vertical. *Anloony* is much less labor-intensive to make than *hol* because there's less resist dying, so it's a much-less-expensive alternative. It makes elegant throw pillows and draperies.

Plaid Silk, Scarves and Wraps

Sarong sot ("sArong sote") is a piece of plaid silk the size of a *sampot* wrapped around the waist instead of sewn into a skirt. It is worn by both men and women, but only inside the house. It's considered a luxury item; most people buy cotton instead. This fabric looks like what is called "Thai silk" in the Western world; hand-woven unpatterned *pamooung* and *sarong sot* made by Khmer Surin in northeastern Thailand were probably the precursors of Thai silk, which is machine made.

Kramaa sot ("kraMAA sote") is a plaid silk scarf, also a luxury item – most people buy cotton instead. (Note: A silk evening wrap, casual wrap or scarf, not plaid, would also be called, "kramaa sot".)

"What about solid-color scarves," you ask, **"and print scarves?** I see Khmer women wearing them." Well, they wear them over their blouses when they go to temple (for modesty) and usually wear imported synthetic ones. These are called *"sbai". **The scarves you see in stores are, for the most part, made for foreign visitors.***

Ikat Silk Tapestries

A *pidan* ("peeDAAN") is an ikat silk tapestry, usually with Buddhist imagery; the latter is hung by all four corners from the ceiling of a temple, or over the bed of a person who is dying. *Pidan* are popular with Japanese and European collectors. See the section on Pidan Khmer in Phnom Penh and Chan Nara across the Mekong for examples (frontispiece, and pages 36 and 41). In Siem Reap, IKTT and Neary Khmer Angkor Shop sell pidan. You may also find them in Saiwa Market in Takeo Province (see the section on visiting silk-weaving villages).

There are actually more different kinds of silk within these six categories, but they are either no longer available, or available by advance order only (and not of particular interest).

Standardizing Silk Classification and Terminology

The classification of traditional Cambodian silk into six categories by pattern type is my own system. When I began my research I quickly discovered that there *is* no classification system. This is because:

1) Cambodian silk is difficult to classify. Should you categorize it by pattern type, by the way it's worn (which determines the pattern scheme), by the dying method (ikat, or not), by the weaving method (twill, *lbauk,* supplemental weft, etc.), by the use of traditional or non-traditional colors, by the use of traditional natural dyes or modern chemical ones, by the geographic origin of the pattern, by the geographic origin of the silkworm that produced the silk, or by something else entirely?

2) Few people know about all the different types of Cambodian silk.

3) Khmer do not see a need to classify things (as Westerners do – a simple difference between their culture and ours), so no classification system ever evolved.

4) Terminology is not standard because modern Khmer is not precise (again, a difference between their culture and ours). Terms are not specific. For example, unpatterned silk, geometric brocade, and "diamond pamooung" chorabab are all called *pamooung.* And spelling and pronunciation are not standard. For example, some people say, *anloony* and others simplify it to, *loong* (dropping the "an" and changing the final consonant).

Cambodian consumers classify silk as simply "hol" or "pamooung", because that is what they buy. But that is imprecise (because, as we've seen, "pamooung" can mean unpatterned silk, geometric brocade or diamond pamooung) and incomplete (it leaves out *chorabab, pidan* and plaid silk, which most consumers never buy because they are luxury goods, and *anloouny*, which consumers don't buy if they can afford *hol)*. Shop owners must speak the same language as their customers, so they perpetuate this simple hol-or-pamooung classification. But they're not the same ethnic group as the weavers; many don't really know much about Cambodian silk – they just know what sells. It's the weavers who use precise nomenclature. But most of them only make one type of silk. You have to talk to people who make *hol, anloouny, pamooung, pamooung* brocade, *chorabab, sarong sot, kramaa sot* and *pidan* before you can even <u>begin</u> to get the whole picture. Simple as my classification scheme may appear, it took me almost a year to come up with it.

More about Chorabab, the Queen of Cambodian Silk

As of 2016, there were only five villages left in which this haute couture fabric was being woven (with the possible exception of diamond pamooung). If you like it, buy it. Because this will be the first type of Cambodian silk to disappear. But, why is it dying out?
1) Because it's so difficult to make, the son or daughter of a master weaver often chooses to pursue a different line of work.
2) Because, by Cambodian standards, it's very expensive, it's quickly being replaced by imported machine-made counterfeits. Worse yet, these counterfeits are usually synthetics.
3) Because, in Cambodia, it's worn primarily by bridal couples, there is little demand for it. "How can that be?", you say, "when almost everyone gets married?". Because bridal ensembles are usually rented from a wedding arranger – right down to the shoes! The couple wears several ensembles during the two- or three-day ceremony, but they are *all* rented. And reused, which greatly reduces the demand.

So, can *you* wear *chorabab* if you're invited to a Cambodian wedding? Yes – for the banquet that concludes the ceremonies (but it must be a *sampot,* not a *lbaab*). Cambodians are aware that foreigners have more discretionary income than they do, and the feeling is, if you can afford it, go for it! But there is, actually, a less-expensive alternative to all-silk chorabab – and that is a blend of silk and cotton.

There are several types of *chorabab,* including these:

❖ 1 color with metallic thread - warp and weft of the same color, with supplemental weft of gold or silver. This type is the one that looks most like the Indian wedding saris we see today.
❖ 2 colors with metallic thread - warp and weft of different colors, with supplemental weft of the weft color and gold or silver. "Diamond *pamooung"* falls into this category.
❖ 3 colors - warp and weft of different colors, with supplemental weft of a third color.
❖ 3 colors with metallic thread - warp and weft of different colors, with supplemental weft of a third color and gold or silver.

Vibrant colors reminiscent of Indian saris are the most popular, but Chan Nara (just a ferry-ride away from Phnom Penh) takes custom orders for naturally-dyed *chorabab.* I was lucky enough to visit them when they'd just finished a *kbun* for a bride – champagne-colored silk that had been dyed with coconut husk, with silver supplemental weft. I think I still dream about that piece.

If you want to buy *chorabab* go to Chan Nara (page 36). Don't go anywhere else. Because counterfeit *chorabab* has worked its way into the five weaving villages where the real thing is made. It's sold to mid- to low-end wedding arrangers (who know it's counterfeit), and foreign tourists (who don't). Chan Nara doesn't handle it. They do sell some synthetics for locals who can't afford silk, and for tourists not looking for silk *(really?),* but ask and they'll tell you what you're looking at.

Machine-made counterfeit chorabab (left),
and handmade Chan Nara chorabab (right)

Both are silk, but the counterfeit piece is only two colors (the authentic one is three), the fabric is flatter and so reflects the light differently, strange horizontal lines are visible, and the pattern doesn't have the depth of interest that the authentic piece does. But the biggest difference is in the feel. The counterfeit piece is uniformly stiff, but the authentic piece isn't – the supplemental weft silk thread is softer than the silk around it.

Twenty members of the Chan family raise silkworms and weave. Many studied at IKTT (page 30) to learn to make *hol* and *pidan*, also for sale. And if they don't have what you're looking for they'll make a few calls, and in ten minutes, they will! Remember, if your budget is feeling battered, they have chorabab in silk and cotton blends.

Now, if you think you have no occasion to wear *chorabab...* Are you about to be the Mother of the Bride? Do you go to museum exhibit openings? How about that gallery that's opening up? Invited to a Cambodian wedding or a Chinese banquet? Red or green is perfect for Christmas dinner or a holiday party. And then there's New Year's, and dinner dances, and... *cruises!* Oh! You'd better buy a *lot!*

And you don't have to make a dress. You can make a short or long jacket to wear over an unpatterned short or long dress. Or a bandeau top to wear over a long skirt (straight or full).

The villages that still make *chorabab* are in Ksach Kandal District:

Prek Takov Commune:
> Prek Ta Kov Village
> Prek Bong Kong Village
> Prek Levia Village

Prek Luong Commune:
> Prek Thaung Village
> Prek Luong Village

If you want to buy a map before you head out you can get one at any bookstore in Phnom Penh, or from the mapseller (below) in the art deco New Market, Psar Thmei. But you don't really need one.

What should I pay for silk?

That depends upon whether or not the piece was woven from hand-spun Khmer golden silk thread (see the section on Khmer Golden Silk in Siem Reap on page 28) or machine-made Vietnamese silk thread, whether it was dyed with natural or chemical dyes, and the intricacy of the pattern and weave.

The best thing to do is to go to the stores I've recommended. I can bet you you won't be overcharged. (I'd suggest you not ask your tour guide where to go, or you may end up paying inflated prices where he gets commission.)

By Western standards, Cambodian couture silk is *not* expensive (except for specialty products, like the larger pieces made by the Institute for Khmer Traditional Textiles). **It's a much better value than any fabric I can buy in the United States.** As I've said, it wears like iron; it's about the thickness of a cotton bedsheet, the fiber is strong (like spider silk), and it doesn't run unless you *really* snag it on something. Moths ignore it. It's colorfast, somewhat stain resistant, doesn't shrink, and irons and drycleans well. Brocade and water don't mix, but getting caught in the rain in ikat, plaid or unpatterned *pamooung* won't ruin it. The intricate patterns are timeless, and hide stains well until you can get to the cleaner's. Ikat silk is infinitely versatile – it goes just as well with jeans as it does over a dinner or evening dress, especially if there's indigo in the pattern. And silk is warm in winter and cool in summer.

Because it does last so long and is made of a renewable resource, it must be one of the most sustainable fabrics on the planet – you don't even need electric power to produce it. But I will caution you about three things:

1) As with any other fabric, do not let stains set in – get your silk to the drycleaner as soon as you can.

2) When ironing it yourself use a steam iron filled with distilled water on the "silk" setting, but *be sure it's hot* before you start to iron – if it leaks you may get a water spot, and your drycleaner may or may not be able to get it out.

3) Covered buttons may look smashing on a silk jacket, but… they get smashed. The forms they use in Cambodia are hollow and crush at the first drycleaning. (You may be able to find solid forms at your local sewing supply store, and take them with you to Cambodia – it's worth the effort.)

So... what do I do when I get in the store?

Before you go in...

Be sure you know how much fabric you'll need for what you want to make.

Tell your driver how long you expect to be. That way he'll know when to start looking for you, and if he'll have time to get a meal.

A traditional greeting

Khmer are very polite – take your cue from them. As the salesperson approaches you press your palms together, raise your fingertips to the level of your lips (don't bow your head), and greet her with, "Choom reab SOO. Soke sabai." (the most polite way to ask after her health). Don't worry about your pronunciation – she'll know by your hands what you're trying to say. And she'll appreciate it.

She'll probably speak some English, but if she doesn't, it doesn't matter. Because there's no English word for what you're looking for. Try asking for the type of silk you'd like to see by the Khmer name. Or point to a picture in this book, or something you see in a case.

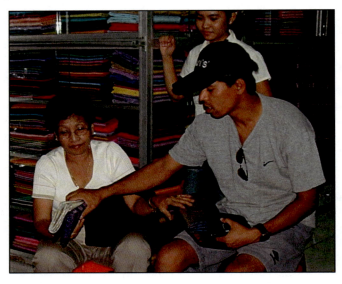

Lang and his mother in a store in Psar Olympic
(note the glass cases full of folded silk)

Traditional silk is sold in three lengths

By kbun: A *kbun* ("kBUN") is approximately 1 X 3.75 metres. Weavers usually don't take a piece off the loom until it's one *kbun* in length, because this is what wholesalers buy. If you want to make a long skirt with a matching top or jacket, you'll need a *kbun*.

By sampot: One *kbun* can be split into two *sampot*, each enough for a long skirt. Buying one *kbun* is more economical than buying two *sampot*, and women will often buy a *kbun*, split it, and give half to a sister or cousin. A salesperson will usually split a *kbun* for you, but if she thinks she can sell the whole piece, she may not (if it's just before wedding season, for example, when the market is most crowded). If you ask her to split a *kbun*, you must buy it – so be sure you've quality-checked it first (see the process chart on page 25.)

By the metre: Only *pamooung* is sold this way, and only in shops that cater to foreigners. Lining, however, is always sold by the metre.

TIP → When buying a *kbun* or *sampo*t, measure both the width and the length to be sure you're getting a full piece. Ask for a discount if you're not.

What to buy to make European-style clothing?

For a **casual wrap skirt**, *hol, anloouny,* or geometric *pamooung* with a white or colored (rather than gold or silver) border.

For a **day dress**, *hol, anloouny,* unpatterned *pamooung,* or geometric *pamooung* with a white or colored border.

For an **evening dress**, *chorabab,* unpatterned *pamooung,* geometric *pamooung* or *hol.* You can use silk organza for the sleeves and / or across the décolletage for a look of refinement and elegance.

For a **woman's or man's jacket**, *hol,* unpatterned *pamooung* or geometric *pamooung.* There are plenty of silver-grey, navy and neutral tones out there for you men. And remember to use that beautiful border! You can run it down each side of the front of the jacket and / or use it at the hemline, and then put more on the cuffs.

If you're not sure if one *sampot* will be enough, buy a *kbun*.

If you're tall, and want to make a long skirt

Ask to see *kbun* for taller women (wider than a metre). You may have to go to Psar Olympic in Phnom Penh – they have the largest selection.

A simple bandeau top
in shades of indigo
dresses up a pair of jeans.

A *hol* jacket can be worn
with jeans, to the office, or for an evening out.
The border has been used down the front, and again on the cuff.

How about Cambodian-style clothing?

For a **sampot**, buy *hol*, geometric *pamooung* or *chorabab*. Have a matching blouse sewn of organza or lace. If you're going to a Buddhist temple buy *hol,* and make a modest blouse with sleeves.

A young lady at a festival, dressed to go inside the temple. Note her temple blouse and scarf, and her ankle-length sampot *with shirring at the waist (created by pulling the hook on the waistband over slightly). The edge of the vertical fold is not ironed. This girl got it right.*

For a **man's shirt,** buy *hol* or geometric *pamooung.*

For a **Cambodian wedding**, buy *hol* or geometric *pamooung* (*chorabab* may also be worn, to the banquet). No black or white.

For a **Cambodian funeral**, buy *pamooung* or *hol* in white (the color of mourning), grey, or black.

Use this simple process to select that perfect piece of silk.

Is the fabric *not* printed (is the design clear on both sides)? Is it folded inside out, in a glass display case?	**no** —>	***RUN!*** Not Cambodian silk.

yes |
v

Turn it right-side out. Is it the color you want?	**no** —>	If it's ikat you can use either side.

yes |
v

Does it have two selvedge edges?	**no** —>	**STOP.** It's been cut. Start over.

yes |
v

Post-war Cambodian silk doesn't "flow." Is the drape right for what you want to have made?	**no** —>	You can hand wash ikat & plaid <u>once</u> in baby shampoo to soften it.

yes |
v

Measure the piece. Is it enough for what you want to have made?	**no** —>	Buy a 1 x 3.75 piece or ask if they have > 1 mtr. pieces for tall women.

yes |
v

Is the size of the pattern repeat OK for your height?	**no** —>	If you're short, try a small repeat or light color

yes |
v

Is the piece without damage & flaws (stains, light spots, fading along fold lines, holes, tears, runs & knots)?	**no** —>	**STOP,** unless your seamstress can work around the problem.

yes |
v

Is the color even across the piece?	**no** —>	**STOP.** Start over.

yes |
v

Is the pattern regular & even? Compare the middle, right & left sides of the border & the field above it.	**no** —>	**STOP.** Start over.

Is it a good piece of silk? If you got this far, *it's a good piece of silk!*

Paying for your purchases

If the salesperson doesn't speak English, she'll tell you the price (in U.S. dollars) by typing it into her calculator and showing it to you. Then, you can bargain. I don't always – it depends upon how near the market rate the price she quoted me is.

You've already quality-checked each piece of silk, but if you bought handbags or other accessories, check those too. Cambodian stores don't take returns; they've never heard of such a thing!

TIP → Like your driver? Hang on to him!

I give mine bottled water and money for his lunch. Because, once I find a good, safe driver, I don't let him get away. Some drivers in Phnom Penh will drive on the wrong side of the road, or turn in front of traffic. If you need to tell your driver not to do this, *tell* him – but politely. He may have thought that what *you* wanted was to get to your destination as quickly as possible! Always be sure he has time to eat.

an ikat dinner dress, using the border at the waist and neckline

Where do I look for silk?

Siem Reap

If you're a visitor to Cambodia you're probably in Siem Reap right now, book in hand. And although this is not the best place to look for silk, you *can* find it – if you know where to go.

You're probably standing at the corner of Pokambor Avenue (the river road along the west bank) and Pi Tnau Street, looking at the tourist market. Psar Chas is about to open its jagged *naga*-like mouth to swallow you alive. But you can be saved.

Turn your back on the market and walk north up the river on Pokambor. Pass the Preah Promreath Pagoda, turn left onto Tep Vong Street, left onto Street 14, then right at the Udara Inn. You'll find yourself looking at a hidden gem – Hup Guan Street, a row of shophouses full of handmade high-quality Cambodian wares. Walk to the end of the street and you'll find a small boutique on your left.

Neary Khmer Angkor Shop, 666 Hup Guan Street
tel. 012-980-588 / 063-964-673
Couture ikat, pidan, *silk by the metre, wraps and accessories*

The owner, Neary, has exceptional taste; take your time here and you'll find some of the best silk that Siem Reap has to offer.

*The owner's mother, Dong, showing a flying parrot design
(note the* pidan *on the back wall)*

27

Neary buys from Khmer in both Southern Cambodia and Northeastern Thailand; ikat is not made in Northern Cambodia (except by IKTT, page 30). Note: Her silk is not displayed in glass cases, but, it *is* silk.

When you've finished your shopping walk back to Pokambor and head north again. Turn left onto Oum Khun Street. A few blocks down, you'll find the Shinta Mani Resort on your right.

The **Shinta Mani** *Made in Cambodia Market,* from 4 p.m. Saturday and Sunday and one evening midweek (check your guidebook for current schedules), is absolutely delightful. Stall after stall of high-quality handmade wares await you in the soft, flickering light of what used to be the French section. This is a fair-trade enterprise, most vendors are Khmer-owned cottage industries, some of the salespeople are the artists themselves, and everyone is friendly. If you miss the market there's a shop inside the resort, or go to AHA (page 30).

At Shinta Mani look for Khmer Golden Silk, one of the few companies that offers products made from the silk of the Cambodian silkworm. Ask for Lina Lem.

Khmer Golden Silk, at Shinta Mani Market on Oum Khun St.
tel. 017-618-885 / 017-440-925
khmergoldensilk@gmail.com
www.khmergoldensilk.com
Naturally-dyed golden silk blankets, wraps and scarves

There are many types of silkworm – Vietnamese, Thai, Japanese, Chinese, etc. – and most make a white cocoon. The Cambodian silkworm makes a yellow cocoon ("Khmer golden silk"). Most silk sold in Cambodia today is woven from machine-made Vietnamese silk thread, but Khmer golden silk is spun by hand from the cocoons of the Cambodian silkworm.

Khmer Golden Silk has taken it a step further. Their weavers make scarves, wraps and blankets from golden silk that has been bleached, then dyed with natural dyes. The chemical dyes applied to Vietnamese thread produce striking, vibrant colors, but there is a time and place for everything – crawl into bed under a soft golden-silk blanket dyed with a wisp of coconut husk and you'll be back at Lina's the next day to buy one for your mom.

They make their wraps soft by using thin thread, a special washing process, and a different weave.

Khmer Golden Silk is based in Phnom Srok District in Banteay Meanchey Province, a couple of hours west of Siem Reap. If you'd like to visit weaving villages in Phnom Srok, see page 35.

Also at Shinta Mani is an organization sponsored by the French NGO Enfants du Mekong that makes stunning evening wraps.

Soieries Du Mekong, at Shinta Mani Market on Oum Khun St.
tel. 093-496-190
contact@ SoieriesDuMekong.com
www.SoieriesDuMekong.com
Cambodian golden silk wraps and scarves, some naturally dyed

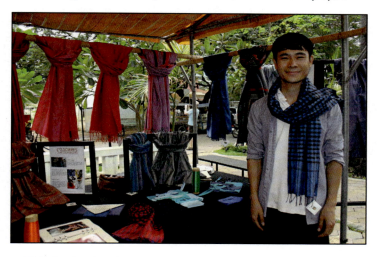

This is also hand-spun Khmer golden silk made in Phnom Srok District. Like Khmer Golden Silk, Soieries Du Mekong makes their wraps and scarves supple by using thin thread and a special washing process. They do offer some naturally-dyed wraps.

Shinta Mani screens its vendors well, so if you buy silk here from someone other than Khmer Golden Silk or Soieries Du Mekong you should be OK. And Siem Reap keeps changing – check the **Artisans' Association of Cambodia** at www.aac.org.kh for new fair-trade sources of genuine Cambodian silk.

TIP → If your schedule for seeing the temples of Angkor gives you only evenings to shop, the Shinta Mani Market and AHA (next page) are the places to go.

The Night Market in the Pub Street area is crowded and noisy, and little of the merchandise is of the quality you'll find at Shinta Mani and AHA. The Night Market is also less safe; many stalls are constructed of highly-flammable materials, the electrical wiring is old, and it's harder to get out in an emergency. Old wiring is a big problem in Cambodia – one year, my hotel caught fire.

If you're looking for more fine craftsmanship, the AHA Khmer Handicrafts Market offers shadow puppets, wood and stone carvings, baskets, pottery, silver and some silk. It's not walking distance from the center of town, so hail a tuk-tuk. Head toward Angkor Park on Road to Angkor, then turn right on Road 60. After the Naga Bridge slide over onto the service road on the right (on the south side of Road 60). You'll see AHA on your right, after the car dealerships.

AHA Khmer Handicrafts Market, Road 60
info@aha-kh.com www.aha-kh.com
Cambodian silk wraps and scarves

You'll find mostly artists at AHA. Because their spaces are permanent (they don't have to set up and tear down each day) you can often catch them at their craft, and can find larger pieces here.
Like Shinta Mani Market, AHA is open evenings.
They screen their vendors well, so if you buy silk here, you're probably OK.

No trip to Siem Reap is complete without a visit to the Institute for Khmer Traditional Textiles. This is walking distance from Psar Chas but, because of the ferocious traffic at the roundabout, you may want to hail a tuk-tuk. From the roundabout take Road to Lake south along the river, and look for the "IKTT" sign on your right.

Institute for Khmer Traditional Textiles, 472 Road to Lake
tel. 063-964-437
iktt.info@gmail.com
www.ikttearth.org
Naturally-dyed Cambodian golden silk
tapestries, wraps, scarves and sampot hol

Mr. Kikuo Morimoto was hired by UNESCO after the fall of the Khmer Rouge to find master weavers who had survived the genocide (weaving was forbidden under the Communist regime). He travelled to weaving villages around the country when travel was still very difficult, and not always safe; he had to abandon his research in parts of the north because there was still fighting between government troops and Khmer Rouge guerillas. In 1995 he compiled a report entitled, *Research Report – Silk Production and Marketing in Cambodia – for UNESCO Cambodia – Revival of Traditional Silk Weaving Project.* Be sure to pick up a copy at IKTT; it gives driving directions to several silk-weaving villages (I've given you the directions to my favorites, beginning on page 45).

Mr. Morimoto went on to establish the Institute for Khmer Traditional Textiles to ensure that traditional weaving survived. He brought master weavers and dyers to Siem Reap from southern Cambodia, and set up a program to enable them to pass on their skills to young people from all over the country.

And he just kept right on going. Having observed the terrible deforestation during and after the fourteen-year Communist period he secured several acres of land off the road to Bantea Srey to establish the Wisdom of the Forest Project. His staff there work to ensure that natural dying techniques, dye formulas, and plants and insects from which dyes are made are not lost forever. If you would like to visit the Wisdom of the Forest Project you can get a map at IKTT. There is also another retail store there, larger than the one in town.

The silk sold at IKTT is all Khmer golden silk, spun by hand, and dyed with natural dyes using traditional techniques. This is a very labor-intensive art, so the end product is expensive. But you should pick up one piece for your collection.

Mr. Morimoto devoted his life to the preservation of traditional Cambodian silkmaking, but as of 2016, that life was slowly coming to an end. IKTT may not be able to survive without him.

It should be noted that IKTT is one of many NGOs in Cambodia – charitable non-profit "non-governmental organizations" that teach vocational skills, create jobs, and put money back into the economy. There are companies in Cambodia that set themselves up to *look* like NGOs that are, in fact, for-profit concerns that may or may not pay fair-trade wages, and whose profits may or may not stay in the country. If you're not sure who you're dealing with, pull up their website and read between the lines to try to figure it out.

Sampot hol *at a weaving demonstration put on by
the Institute of Khmer Traditional Textiles
(note the intricacy of the design)*

A weaver at the Wisdom of the Forest Project

Closeup of an ikat design element in one of IKTT's pieces.
Their dyers use banana-fiber ties in the resist-dying process.

Beware the Great Impersonator – *Rayon!*

It was Mr. Morimoto who first told me of the encroachment of rayon into the silk industry. Other sources with whom I consulted during my research corroborated his statement.

Why rayon? Because it's very difficult to distinguish from silk.

Silk buyers in Cambodia use a tried-and-true method to determine if the weaver they're buying from is selling them real silk. They pull out a warp and a weft thread from the piece, and burn the two. If they're left with ash, the thread is either silk, cotton, or a blend of the two. If they're left with melted thread, however, the thread is synthetic.

So what's the problem? Rayon, although synthetic, is made from cellulose, a carbohydrate found in plant cells. When burned, it leaves ash behind. So the silk buyer's tried-and-true method no longer works. For *anyone.*

Add to this that most tourists are looking for Cambodian silk, but they're looking for what they *think* it is – a fabric like the soft, flowing silk of Italy, France, China or Japan. Rayon can be made to look and feel like *just that.* Add to this that most tourists are not after couture Cambodian silk (they don't know it exists), but *scarves.* My advice is, if you're looking for soft, flowing scarves, buy from Khmer Golden Silk or Soieries Du Mekong; I've described their softening techniques. And you can wash ikat and plaid Cambodian silk in baby shampoo to soften it slightly (wash it only once, so as not to lose the sheen).

TIP → If a store tells you they carry pashmina, well, they *think* they do...

Let me tell you a story. We were in Kathmandu, and it was *cold.* A sweet, middle-aged shopkeeper asked if we wanted to buy woolen hats. We said we'd already bought some, and that they were made of yarn spun from baby yak fur.

"Ooooooooh," he said. "Cheeeeeating!" Pause. "How many days you been in Kathmandu?" We told him we'd been there a week. "How many yak you seen running around?" We looked at each other. None.

So, how many Tibetan goats you seen running around Siem Reap? Yes, the "pashmina" on the shelves is imported, but not from the Himalayas. Cambodians have no experience with wool of any kind. A shop owner thinks that what he bought is pashmina because the foreign guy who sold it to him swore it was.

Oops! Are you in a store not on my list?

And you're not... quite... sure... how you got there? You're with a tour, and your tour guide gets commission on everything you buy. And the more they can get you to pay for your silk, the more he, and the store, will make. So now you understand why you don't see any price tags. Make a graceful exit and wait outside the front door until your tourmates have finished their shopping – that way, you won't have to deal with the sales people.

Psar Leuu (traditional Khmer jewelry, ikat and geometric brocade)

If you can squeeze a few hours out of your schedule, go east on National Road 6 to where the locals shop – Psar Leuu. This is a one-story market with relatively wide aisles. Some stores sell couture ikat silk and geometric brocade, but what I'm sending you here for is jewelry. Since 1975 (the fall of the country to the Khmer Rouge), traditional Khmer jewelry has been extremely difficult to find. But, if you look hard enough, you can find it here. Walk straight to the middle – the goldsmiths' counters. Look for crown-shaped rings ("princess rings") of diamonds or zircons with rubies or sapphires, dainty Khmer drop earrings, and graceful bracelets. You do have to be patient and look hard, but an appraiser once told me to think of it this way – you'll have the piece for the rest of your life, and can pass it on to your children. And not everything here is expensive – the first time I went to Psar Leuu I came out with a lovely pair of zircon earrings for which I paid only $35.

TIP → *Best tour guide for the Angkorian temples*

Mr. Seng Dalign ("Ling"), www.AngkorHappyTour.com
sengdalign@yahoo.com info@angkorhappytour
tel. 012-869-365
He can also take you to weaving villages in Phnom Srok District.
If he's already booked, he'll find you another guide.

Best tuk-tuk driver in Siem Reap

Mr. Sy Vutha Walter ("Walter")
vuthasy@yahoo.com
tel. 092-615-956

Ah – the big city. Phnom Penh is the best place in Cambodia from which to search for that perfect piece of silk. Because there is more of it here than anywhere else. And because you can get all of the different kinds here – ikat silk, unpatterned silk, silk brocade, and even hand-woven hand-embroidered organza.

Start with Chan Nara. Hail a tuk-tuk on Sisowath Quay, hop the ferry across the Mekong just south of the Sokha Hotel (by the time you read this there may be a bridge there), and then go up the river road on the east bank (Road 380). When you get to Prek Bon Kong Village your driver can ask for directions (the turn isn't marked, but if you see a temple with 2 large shrimp statues, you've gone too far), or telephone Chan Nara. When your driver finds the street, be sure he passes the RED sign and stops at the GREEN one (!).

If you want to buy a map before you head out for Ksach Kandal District, you can get one at any bookstore in Phnom Penh or from the mapseller in Psar Thmei. But you don't really need one.

Chan Nara, Prek Bong Kong Village, Prek Takov Commune, Ksach Kandal District, Kandal Province

Seiha_Silk@yahoo.com
tel. 017-730-378 / 010-350-878 / 097-339-3783
Haute couture *floral brocade (**see the two sections on** chorabab),* *couture geometric brocade, couture ikat and ikat tapestries, wraps and scarves, some Cambodian golden silk*

Nara showing a colorful pidan *with a Buddhist theme.*

For the largest selection of ikat couture silk, go to Phnom Penh's largest public market.

Psar Olympic (French pronunciation, "Psaa OlymPEEK"), **Street 286** (near the Olympic Stadium)
Couture ikat and geometric brocade, cotton lining material (stall 80)

STOP! Read this before you set out!

This is a HUGE public market. It's a fire trap, it's easy to get lost, it's *hot,* you can slip on a fish scale and whack your head on the cement floor, a power outage is not unheard of, and I *know* there are rats in there somewhere.

That said, you really ought to see it. Because it's typical of the places where people in large cities in Southeast Asia shop. As these countries become more developed, and more Westernized, these old markets will disappear. There are already three malls in Phnom Penh.

- Plan to go early in the morning, when it's still relatively cool.
- Go with someone else (who speaks Khmer, if you can arrange it).
- Pack water and snacks.
- Don't forget your measuring tape.
- Take your phone, and be sure you have your driver's number!
- Pack a flashlight in case of a power outage (or use your phone).
- Be sure you will not need to use a restroom.
- Plan to go in the main Street 286 entrance so you know where you went in. If you come out of a different entrance when you've finished your shopping, you'll never find your driver.
- Pack a compass, in case you DO come out the wrong entrance.

OK, so you look like Indian Jones. At least you'll be safe.

Be sure to tell your tuk-tuk driver to wait for you.

Once inside the market, go to the second floor. You'll find yourself surrounded by silk, floor to ceiling. Each shop is nestled into a rectangular space open to the aisle. You'll see piles of fabric on the floor – these are synthetics, for people who cannot afford silk. There will be piles of blouse material, too, especially white cotton – many Khmer women wear a white cotton blouse to temple. Most of the silk sold in this market is what is in most demand by Cambodian women, for wearing to temple and weddings – *sampot hol.*

The lace section.
The photo on page 20 was also taken in Psar Olympic.

So now you're in *hol* heaven. Your first challenge will be to find the color you want, because you can't see the color of the right side of the fabric until the piece is unfolded *(hol* is darker on the flip side because it's a twill weave). But you can use <u>either</u> side. I once dragged my husband through monsoon rains on the back of a motorbike to a market in the middle of nowhere, and found the loveliest piece of *hol* I'd ever seen. But I liked the wrong side. I bought a *kbun* and took it to a seamstress to have a jacket made. Next thing I knew my husband had her in a corner – they were plotting something. He actually *designed a dinner dress for me,* and the seamstress made it out of the leftover silk – because *he* liked the right side! (You can see the dress on page 26.)

Your next challenge will be to find the border width you want. I think the border is the prettiest part of the piece, so I always buy a border at least seven cm. wide. If you're shopping for a gift for an older Cambodian, however, go with a narrow border (and muted colors).

Take your time to select your pieces, and buy as much as you can afford. What you see in this market is <u>*good* hol</u> – because the Cambodian women who shop here know what good *hol* <u>*is*</u>. You'll still have to use the process chart I made for you when you select each piece (page 25), but you're more likely to actually get to the end of it!

Psar Thmei, eastern terminus of **Kampuchea Krom Boulevard**
Couture ikat, geometric brocade, silk blankets

If you're not *quite* up for a trip to Psar Olympic, head for the art deco Psar Thmei. It's a much smaller market, but you still must be sure you know which entrance you came in. It's an odd bird – both tourists and locals shop here. And the salespeople know which one *you* are. Beware of synthetics, no matter how vehemently a salesperson insists that the piece you're looking at is silk. If you stick to looking at *sampot hol* and *pamooung bauntok chorjuung*, however, you should be OK.

Koh Dach (the "Silk Island") & Koh Ooknyatei

Koh Dach ("the Island that Split Off") is one of three islands in the Mekong in a district of Phnom Penh northeast of Sisowath Quay. Cross the Japanese Friendship Bridge, go north on National Road 6 and catch the Koh Dach ferry. Go over the rattling metal bridge off the southeast shore of Koh Dach and you're on Koh Ooknyatei.

*Lang distributing reading glasses and medicine
(with Khmer labels) to weavers on Koh Dach.
Note the loom behind the younger woman.*

Although fine *pamooung, pamooung* geometric brocade, diamond pamooung and *anloouny* used to be woven on these two islands, most of what's woven here now is synthetics in simple patterns. What silk there is is taken to Phnom Penh to be sold, and the seller returns with machine-made synthetic scarves and wraps made in China, India, Vietnam or Thailand. They tell tourists it's Cambodian silk.

Things may change; in 2016, some weavers were switching back to silk. But let me share my experience with trying to buy fabrics here.

The first time, I bought an unusual brocade in an exquisite blue. Once back in the U.S. I opened the bag only to find that they'd switched the piece for an ordinary one of a different color.

The second time, I bought *anloouny* that the weaver assured me was 100% cotton. It was dusk, and the light in her house wasn't good. Once back home I opened the bag to find that the piece was synthetic.

The third time, a weaver showed me a lovely brocade. When I unfolded it I saw fading along the fold lines (she hadn't stored it inside out). She couldn't sell it in Phnom Penh because of the damage, but thought she could sell it to me – at full price.

The fourth time, a weaver showed me a perfect piece of brocade. But when I pulled out a $100 bill, the price suddenly went up by $10.

There won't be a fifth time.

And I've been given bad information on Koh Dach. I once bought a diamond pamooung with a classic *chorabab* border of Angkor Wat spires and Bantea Srey banding (both old Khmer patterns). The seller told me the piece was locally made, but the pattern was the very latest design – from Thailand. *Really?*

TIP → If you're on either island and want to buy silk, you can easily get to Chan Nara (page 36). Take the ferry from the east shore of Koh Ooknyatei to the east bank of the Mekong and go to Prek Bon Kong Village from there. You can return to Phnom Penh on the ferry that runs from the east bank of the Mekong to Sisowath Quay just south of the Sokha Hotel.

Koh Dach is, however, a lovely place to get a glimpse of village life, and the views of the Mekong are spectacular. Try **Villa Koh Dach** guesthouse on the eastern side of the island (just south of the market where the fishing boats come in) for fine French food in a garden setting served by a truly charming staff. If you overnight in one of their comfortable upstairs rooms, you can walk to the market to catch the sunrise and then bike around the island.

No trip to Phnom Penh is complete without a visit to Pidan Khmer.

Pidan Khmer, Street 63 at Street 278
(on Street 63 in the middle of the block)
www.pidankhmer.org
info@pidankhmer.org
tel. 023-210-849
Museum-quality pidan, *first-quality naturally-dyed couture ikat silk, ready-made clothing, and handbags, scarves and other accessories*

This Japanese NGO trains weavers in Takeo Province to make the extraordinarily-intricate *pidan* of generations past, ensuring that these old patterns are not lost. They also offer lovely products for the modern woman – business card holders, ikat clutches, totes, and lots more. Plenty of scarves in neutral tones and neckties for the guys. And they use only natural dyes! Have their phone number handy, because your tuk-tuk driver may have difficulty finding the store.

Their silk is not displayed in glass cases, but, it's all silk (they carry no synthetics at all).

photo courtesy of Pidan Khmer

An exceptionally fine Buddhist ikat silk tapestry of four nagas

What I come to Pidan Khmer for is their first-quality naturally-dyed couture ikat silk. If you're going to a Cambodian event where you need to look just right, visit Pidan Khmer first.

© Tadashi Kumagai photo courtesy of **Pidan Khmer**

This fine sampot hol *has been naturally dyed
with resin produced by the lac insect,
wood of the* prohout *tree, annatto seed and ebony fruit*

photo courtesy of **Pidan Khmer**

An elegant ikat business card holder (ask for a "name card case")

Quick Shopping Guide – Where to find <u>real</u> Cambodian silk!

Product	Siem Reap	Phnom Penh
silk blankets	Khmer Golden Silk IKTT	Psar Thmei
scarves & wraps	Khmer Golden Silk Soieries du Mekong Neary Khmer Angkor IKTT	Chan Nara
accessories, like ikat handbags	Neary Khmer Angkor	Pidan Khmer
men's neckties	IKTT, and the 5-star hotels	Pidan Khmer
couture ikat	Neary Khmer Angkor Psar Leuu IKTT	Pidan Khmer Psar Olympic
floral brocade	----	Chan Nara
geometric brocade	Neary Khmer Angkor Psar Leuu	Chan Nara Psar Olympic Psar Thmei
unpatterned silk	Neary Khmer Angkor Psar Leuu	Psar Olympic Psar Thmei
pidan (ikat tapestries)	Neary Khmer Angkor IKTT	Pidan Khmer Chan Nara
ikat for men's shirts	Neary Khmer Angkor Psar Leuu	Pidan Khmer Psar Olympic Psar Thmei

Resist-dyed silk thread hung out to dry in Prai Changkran

Ready? Head out for a weaving village!

Not only do I want to keep Cambodian weavers working, I want to keep them working at *home*. They set up their looms under their stilt houses, and have some of the best working conditions in the world – they can work their own hours and care for their children and their parents, they have fresh air and sunshine, and they're not exposed to the dangers of city life. I'd like to help keep it that way. So I'm sending you out of town – to the weaving villages of the south.

Buy a map the day before you leave Phnom Penh (you can get one at any bookstore, or at the mapseller's in Psar Thmei) and **mark your route**. Note that spellings are not standard; for example, Prai Changkran may appear on your map as Prek Changkran, or Preaek Changkran. Route numbers sometimes change. And there are many places that have the same name. Your driver will, most probably, not be able to read a map, so you may have to direct him. Be sure **you** always know where you are. I take a compass, just in case.

Go in a vehicle that has **reliable air conditioning**, and take **snacks** and plenty of **water**. If you're taking a day trip to Takeo Province or Prey Veng Province, pack a lunch too.

You may or may not be able to buy silk at your destination, depending upon when the weavers last took their pieces to market or a wholesale buyer swept through. Kandal and Takeo are your best bet, but Prey Veng is prettier, quieter, and cooler (more trees).

Takeo Province *(couture ikat and ikat silk tapestries)*

Takeo, a day trip from Phnom Penh, is where most couture ikat is made. Go south on National Road 2 and turn left (east) at Thnol To Teng Market in Samrong District, north of the provincial capital. There is a 20-km. stretch of road between here and Prey Kabas District where there are several weaving villages – Samrong, Sla Kanlek, Kandal, Trapeang Sdok, Ampil, Krachang, Chumrou, Saiwa, Ampil Kanlek, Trapeang Sway and Reussey Thmey. You should be able to buy silk right off the loom. *(If you can't locate these villages on your map before leaving Phnom Penh, don't go.)*

TIP → There's a large market in Saiwa where you may be able to find pidan (if the collectors haven't beaten you to it). Go very early in the morning, when the locals shop, for a truly-Cambodian experience.

Prey Veng Province *(couture ikat)*

Also a day trip from Phnom Penh are Prai Changkran and Prai Sandai villages in Sithor Kandal District, in the northern tip of Prey Veng Province. From the Sisowath Quay area go east over the Japanese Friendship Bridge, north on National Road 6, and east across the Mekong on the Prek Ta Meak Bridge onto National Road 8. Follow 8 into Prey Veng Province, turn left onto Road 314 at Prey Pnov, and go north to the border of Kampong Cham Province (don't cross the border). This will take you into Prai Changkran. Your driver can ask for directions to Prai Sandai from there. *(If you can't locate these villages on your map before leaving Phnom Penh, don't go.)*

These houses in Prai Changkran are more than 100 years old

Now, most people will tell you that Prai Changkran and Prai Sandai are in Kampong Cham. Before the Prek Ta Meak Bridge was built, silk from these villages was delivered to Phnom Penh from Kampong Cham. So everyone thought that that's where it was made.

Kandal Province *(floral & geometric brocade, pamooung, organza)*

Head for Ksach Kandal District, and head for Chan Nara first (see page 36 for directions). The villages that still make *chorabab* are in Ksach Kandal district:

Prek Takov Commune:
> Prek Ta Kov Village
> Prek Bong Kong Village
> Prek Levia Village

Prek Luong Commune:
> Prek Thaung Village
> Prek Luong Village

Some weavers in these villages make *pamooung* and geometric brocade. You may or may not be able to find organza.

A twelve-year-old boy helping Mom after school

There are many more weaving villages than I've listed here. For more information and directions, pick up Kikuo Morimoto's <u>Research Report – Silk Production and Marketing in Cambodia for UNESCO Cambodia</u> at the Institute for Khmer Traditional Textiles in Siem Reap. Or, you can read it at the library at Wat Damnak in Siem Reap.

And do you know *how* you know that your silk was made in a village? When you iron it for the first time, a smoky smell comes up with the steam. That's the weaver's cook fire (usually near the loom).

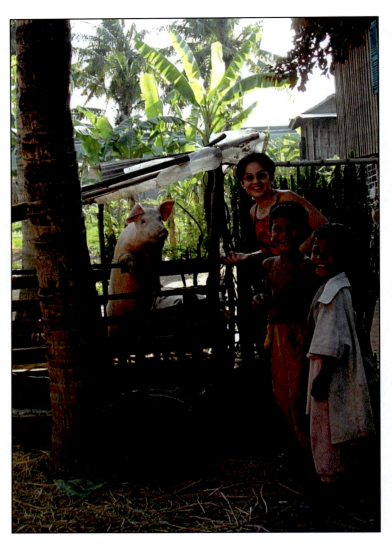

The author getting another TERRIBLY important interview,
this time in Lang's village in Kandal

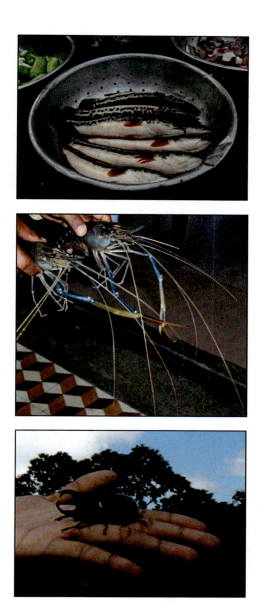

The designs in silk come from things that surround the village weaver.

Seamstresses

Most foreign visitors are in Cambodia in the cool season – November, December, January and February. And that's "wedding season" – it's right after the rice harvest. Let me share my experience with you again.

My seamstress retired, and I was looking for another. One was recommended to me, and I had her make a *sampot*. I got it back, and was delighted to find she'd done a perfect job. Two weeks later I had her make another. But by then she was flooded with orders from people who wanted new *sampots* to wear to weddings. I got mine back and found she'd done a rush job – the hem was too narrow, she'd straight-stitched it, and everything was crooked. But at least it was "fixable". In recent years seamstresses have started lining garments by fusing synthetic fabric to the reverse side of the silk. Not fixable.

That said, you may be able to get a recommendation for a good seamstress from the concierge at one of the five-star hotels. But if you travel a lot, you might try this. Have your seamstress at home make a pattern for you before you leave. Give the pattern to the seamstress abroad (remind her that you'll need it back). If you're in Phnom Penh you can buy cotton lining at Psar Olympic (stall 80), and give that to her, too (otherwise, you'll end up with hot synthetic). Ask her to return all of the silk she doesn't use – there's often enough for a bandeau top, a handbag, or piping for a blouse.

But is having your clothes custom made really worth the effort? Yes, it is – because they last so much longer. There's less stress on the seams because the garment fits better. And they're more comfortable.

Hey! Did we forget you guys?

Oh, no, we did not. Consider for a minute that most men do *not* like to shop. And that Cambodian silk wears like iron. If you have a half-dozen shirts made of ikat, you'll be set for dress occasions that don't mandate a suit for *years*. Lang likes to wear his to festivals, like the Himalayan Fair and Indian Mela in the San Francisco area. And he stocks up on scarves because silk is warm in winter. One visitor told me he bought a spring-green *anloouny* bathrobe as a reminder of Cambodia's velvet-green rice fields. And neckties? Go to Pidan Khmer in Phnom Penh, or try the five-star hotels.

Take it from Lang – yes, you have to shop once in awhile, but shopping in Cambodia is a *lot* more fun than shopping anywhere else.

For the man on your list, a naturally-dyed silk scarf

This ikat from Pidan Khmer would make a great man's shirt. It's been dyed with tamarind, prohout *wood and ebony fruit.*

Traveling to Angkor Wat?

You can drop off badly-needed reading glasses (new or used).

This recipient is a landmine victim, a double amputee.

A person's ability to see his work determines when he must retire. One pair of reading glasses can perpetuate the income of an entire family, and give an artisan with a skill that's dying out more years to pass his knowledge on. We've arranged two drop-off points for you:

Wat Bo – This Buddhist monastery runs a school for underprivileged boys and teaches the traditional Khmer arts. From Wat Bo Street turn east on Achar Mean Street; the temple gate is at the end. Ask for the abbot, Preahmaha Pinsem. They also need boys' clothes, new or used.

IKTT – Go south on *Road to Lake* to #472 (look for the IKTT sign on the right). Ask for Mr. Morimoto's assistant in the gift shop (second floor).

Wherever you go in the world,
you can make a difference.

You can collect reading glasses
from your friends and officemates before you leave,
and drop them off
at a religious institution or library at your destination.
Explain that you'd like them to distribute the glasses
to those who can't afford them.

It will be the best part of your journey.

Made in the USA
San Bernardino, CA
28 October 2016